Emblems of the Passing World

Emblems
of the
Passing World

Poems after Photographs
by August Sander

A D A M K I R S C H

Other Press *New York*

August Sander photographs: © 2015 Die Photographische Sammlung /
SK Stiftung Kultur—August Sander Archiv, Cologne / ARS, NY
Scans: LUP AG, Cologne

Production editor: Yvonne E. Cárdenas
Designer: Julie Fry
This book was set in Miller.

10 9 8 7 6 5 4 3 2 1

Library of Congress Cataloging-in-Publication Data
Kirsch, Adam, 1976–
 [Poems. Selections]
 Emblems of the passing world : poems after photographs
by August Sander / Adam Kirsch.
 pages ; cm
 ISBN 978-1-59051-734-5 (hardcover) —
ISBN 978-1-59051-735-2 (ebook)
 I. Title.
 PS3611.I77A6 2015b
 811'.6—dc23
 2015027827

Contents

Introduction ix

I.

The Man of the Soil *3*
The Butcher's Apprentice *5*
Office Worker *7*
Match-seller *9*
Fitter *11*
Farming Couple – Propriety and Harmony *13*
Bricklayer *15*
Working-class Country Children *17*

II.

Middle-class Child *21*

Professional Middle-class Couple *23*

Society Lady *25*

Tannery Owners *27*

Skilled Tradesman and His Wife *29*

Student of Philosophy *31*

The Woman of Progressive Intellect *33*

The Philosopher *35*

Aviator *37*

Gasmen *39*

Laboratory Technician *43*

Master Shoemaker *45*

Kinetics Researcher from Vienna *47*

III.

Small-town Women *51*

Working-class Mother *53*

Widow with Her Sons *55*

Painter's Wife *57*

Farm Woman and Her Children *59*

Confirmation Candidate *61*

Farming Family *63*

Clergyman and Wife *67*

Mother and Child *71*

My Wife in Joy and Sorrow *75*

Girl *79*

IV.

Leader of a Splinter Party *83*
Member of Parliament (Democrat) *85*
Iceland Scholar and University Librarian *87*
Revolutionaries *91*
Village Schoolteacher *93*
Young Farmers *95*
Fraternity Student *99*
Military Height Differences *101*
Blind Children at Their Lessons *103*
Explosion Victim *105*
Matter *107*
Farmer Sowing *109*
Merchant's Clerk *111*
Photographer *115*

Acknowledgments *117*

Introduction

THE PHOTOGRAPHS OF AUGUST SANDER are the opposite of snapshots — not just formally, in the sense that they are austerely composed, but above all in their attitude toward time. The snapshot is meant to preserve not just an image but the moment of its taking; its intention is not documentary so much as memorial, and when we look at it we are remembering more than we are actually seeing. That is why the experience of looking at very old snapshots — say, from our grandparents' youth — is uncanny; the form of the photo encourages remembrance, but the content remains outside our memory. The snapshot represents redeemed time, but the redemption is tied to the individual experience of the photographer and the subject. Unlike a work of art, it is mortal and private.

Sander's portraits counter time in a different way, by defying it. The subjects of his photographs are not given their real names; we are told nothing about where they were taken or under what circumstances; as for dating, we learn the year, or a range of years, rather than a specific day. This is because Sander means us to see, more than the individual, the type he or she instantiates — a type that is the product of class, occupation, gender, family role. *People of the Twentieth Century*, the overall title he gave to his massive portfolio of documentary portraits, suggests a historian's ambition. A middle-class mother, a laborer, a beggar, an industrialist: come back and photograph them again tomorrow, or in ten years, and they would remain the same, unlike the subject of a snapshot, who is always mobile. They will continue to play out the role destiny assigned them until, at the end, they are reduced to the universality of what Sander calls "matter."

But of course, nothing human can be so static. Inside the social function there is the human subject; inside the clothes and accoutrements by which Sander's sitters are labeled and identified, there is the face. The faces in Sander's portraits drag them back toward the realm of the snapshot, of the memorial, even as everything else tries to fix them in the realm of the document, or of art. And it is this duality that makes Sander's portraits so fertile for the imagination. In them, we see what is ordinarily hidden from us — the way we ourselves appear, and will appear to posterity, as types, when we stubbornly insist

on experiencing ourselves as individuals. Like the physicist who sees energy as both particle and wave, Sander sees his sitters, and compels us to see them, as both subjects and objects.

Another way of putting this is that Sander's photographs make history visible. And perhaps they could only have been the product of a time and place where history pressed the individual with unbearable force: Germany in the first half of the twentieth century. Above all, it is the spirit of Weimar Germany that seems to be the spirit of Sander's work: the extreme polarization of tradition and modernity, liberalism and reaction, rich and poor, bourgeois and proletarian, left and right. Here is a painter's wife dressing up provocatively in trousers, and there a girl going demurely to her First Communion; cultured middle-class professionals gaze amiably at farmers wearing city clothes and belligerent expressions; a pilot embodies the glamour of technological progress, while a farmer casts seed by hand into a furrow. It is such contrasts that make Weimar still serve as a symbolic shorthand for modernity itself—especially now that we have entered a postmodernity in which all distinctions are muted and blurred.

Yet August Sander lived from 1876 to 1964, which means that his photographs record not just the Weimar Republic, but the whole succession of traumas and horrors that defined Germany in the twentieth century: the First World War, Weimar, the Third Reich, the Second World War, and the Cold War reconstruction thereafter. None of

Sander's photographs is complete without reference to the history taking place just beyond the lens — the dynamic events that set the static portraits into motion.

For history is about to scatter these lives into the inconceivable guilt and destruction of the German twentieth century, even as Sander's lens struggles to fix them into the permanence of the typical. The clerk photographed in 1912 is on the verge of being killed on the Western Front. An infant boy photographed in the early 1920s will in all likelihood spend his teenage years in the Hitler Youth, his young manhood in the Wehrmacht, or worse. That, at least, is what the statistics can predict. But the exact fate of the individual portrayed in the photograph, his or her choices and sufferings, remains a blank — or else what Robert Lowell called "a loophole for the soul." It is this blank that the imagination of the viewer is compelled to try to fill, with hypotheses or narratives — or, in this book, poems.

Emblems of the Passing World

I.

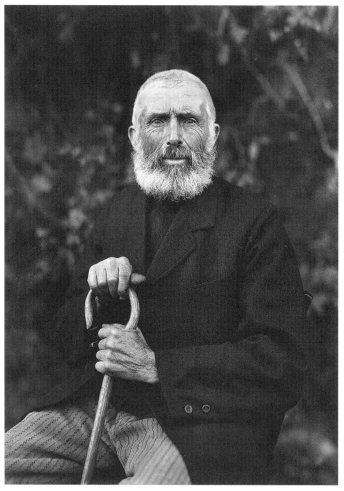

The Man of the Soil, 1910

The Man of the Soil

After so many decades in the sun,
The man of the soil begins to look like soil —
His wrinkles furrows and his hands the brown
Of the resisting earth it was his toil
And craft to trick into fertility,
And into which he is prepared to merge
Now that encroachments of senility
Keep him from drawing forth the surplusage
Upon which the philosophers and priests,
The men of business and their houseproud wives,
And all the rest we are about to meet
Must batten for their unproductive lives.
He claims the pride of place as Adam's curse,
Inscribed upon the entrance to the field,
Comes first in the economy of force
Without whose dull compulsion nothing yields.

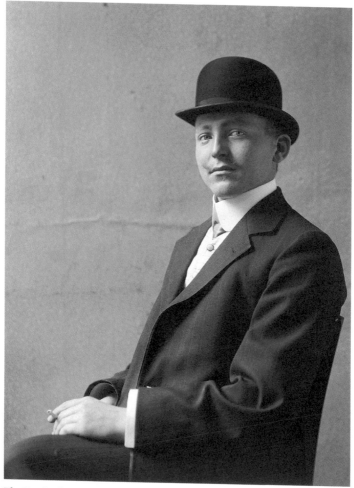

The Butcher's Apprentice, 1911–14

The Butcher's Apprentice

The high white collar and the bowler hat,
The black coat of respectability,
The starched cuff and the brandished cigarette
Are what he has decided we will see,
Though in the closet hangs an apron flecked
With bits of brain beside the rubber boots
Stained bloody brown from wading through the slick
That by the end of every workday coats
The killing floor he stands on. He declines
To illustrate as in a children's book
The work he does, although it will define
Him every time the photograph he took
Is shown and captioned for posterity —
Even as his proud eyes and carriage say
That what he is is not what he would be,
In a just world where no one had to slay.

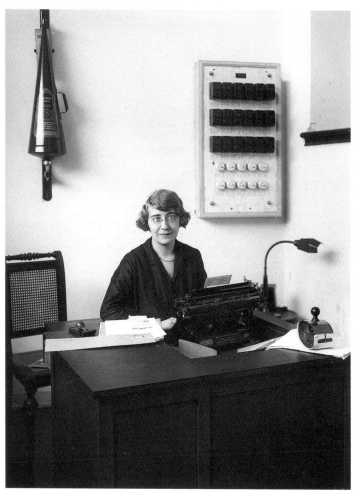

Office Worker, circa 1928

Office Worker

What was the use of the inverted cone
That floats surreally above her desk
Like an umbrella or a megaphone
Of blackened metal? No one's left to ask,
Or tell how she would operate the tiers
Of dials and boxes bristling on the wall
Which look already as in twenty years
Her typewriter will: illegible
As all those emblems that the Renaissance
Littered its portraits with like business cards.
The obsolescence of her instruments
Explains more clearly than she could in words
What work it is she does: the management
Of paper and the hurrying of time
Down the deep hole where all her colleagues went
And where we'll go, whose labor is the same.

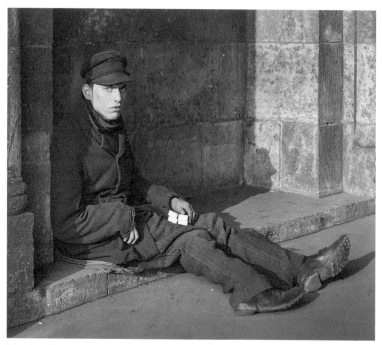

Match-seller, 1927

Match-seller

Because a man with nothing left to sell
Is an abstraction that cannot exist
As long as there's a purchaser who will
Pay him to be a slave or orifice,
The destitute must play at the charade
Of taking part in the economy
With two-cent matches that he has displayed
In an attempt to claim the dignity
Of the small businessman who would recoil
To pass him on the street and realize
How easily the petty-bourgeois fall
Into the class they're brought up to despise—
The honest poor whose honesty consists
Of reassuring the uneasy rich
They won't get angry or vote Communist
As long as someone comes to buy a match.

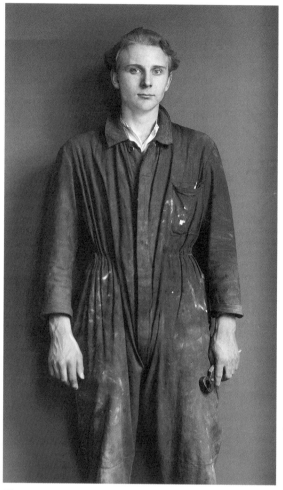

Fitter, 1929

Fitter

Nature plays havoc with the stratified
Society we struggle to impose,
Mounting rebellions on behalf of those
Whose natural equality's denied

By planting beauty like a bomb or mine
In such a man, whose clothes declare his trade
Is dirty, difficult, and badly paid,
But whose bright face and golden hair define

Him as the natural aristocrat
Everyone wants to be with or to be.
He stares with a bemused immodesty,
Assured, no matter who he's staring at,

He's winning in the one arena where
The game's not rigged in favor of the rich;
Money won't buy the privileges which
The beautiful don't earn and cannot share.

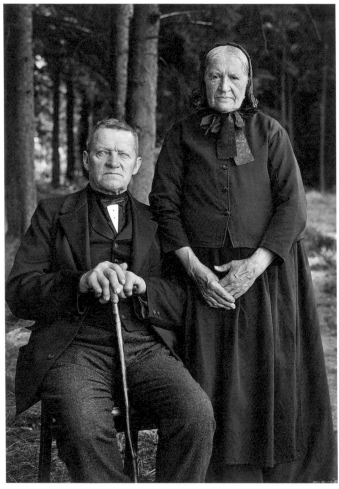

Farming Couple – Propriety and Harmony, 1912

Farming Couple – Propriety and Harmony

What if his red and flattened nose betrays
In broken veins a life of drunkenness,
Whose consequences linger in her gaze
Of fearful acquiescence?

What if her hands are snaked and varicose,
His broken finger healed forever bent —
Small visible stigmata that disclose
What lives of labor meant?

Propriety is not unbrokenness
But a stern imposition of the will,
As they amid their lives' disharmonies
Stand resolutely still.

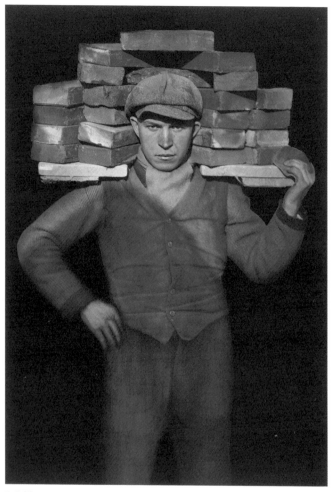

Bricklayer, 1928

Bricklayer

Before the architect can contemplate
Strategic harmonies of line and mass,
Before the engineer can calculate
The densities required to bear the stress,

Must come the laborer, who bears them up
As surely as the stack of twenty bricks
He wears as nonchalantly as a cap
Piled on a board across his back and neck;

Reduced to nothing but a quantity
Of muscle power, his defiant staring
Announces the heroic certainty
That he can bear a life of only bearing.

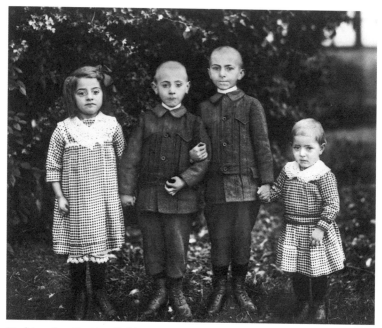

Working-class Country Children, 1914

Working-class Country Children

Days spent out of doors
At hard but useful labor
Are meant to give the poor
The kind of suntanned vigor

Envied by managers
In temperature-controlled
Cubicles who hunger
For bare feet and the gold

Complexion that's denied
To these, whose shaven heads
And eyes set far too wide
Suggest that they've been fed

A vitaminless food,
And made to stay inside
Until whatever should
Have made them golden died.

II.

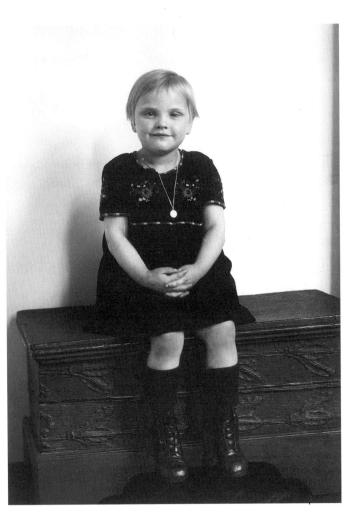

Middle-class Child, 1926

Middle-class Child

The rain of gifts in which the child has grown
Can be deduced from her small bright medallion,
Her brand-new shoes, her black dress gay with braid,
But most from the instinctive way she's laid
Her hands contentedly across her lap,
Confident she won't need to hit or grab
To get the good things life has promised her.
How could she know it's dangerous to wear
A smile so merry and self-satisfied,
When all her life has been arranged to hide
The possibility of nemesis
And put off the discovery of loss?
Who could rebuke her when she acts as if
She thought she were herself the greatest gift?

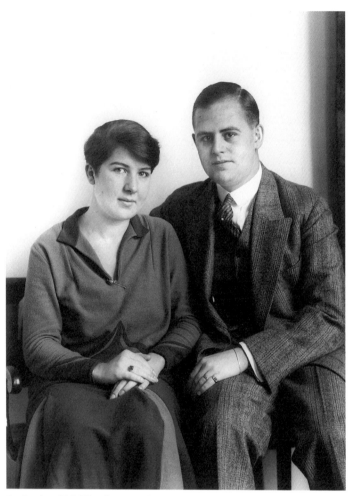

Professional Middle-class Couple, 1927

Professional Middle-class Couple

What justifies the inequality
That issues her a tastefully square-cut
Ruby for her finger, him a suit
Whose rumpled, unemphatic dignity
Betrays a life of working sitting down,
While someone in a sweatshop has to squint
And palsy sewing, and a continent
Sheds blood to pry the gemstone from the ground,
Could not be justice. Nothing but the use
To which they put prosperity can speak
In their defense: the faces money makes,
They demonstrate, don't have to be obtuse,
Entitled, vapid, arrogantly strong;
Only among the burghers do you find
A glance so frank, engaging, and refined,
So tentative, so conscious of its wrong.

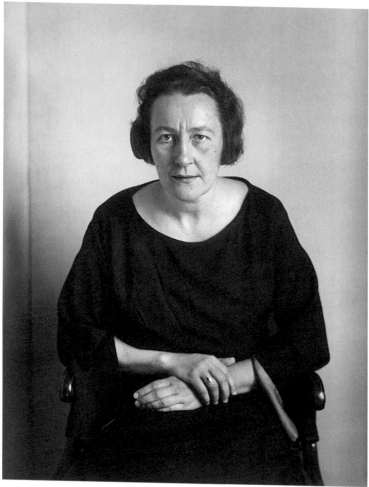

Society Lady, circa 1930

Society Lady

A portrait gallery of duchesses
Would be unrecognizable without
The couturiers and wardrobe mistresses
Who draped the anorexic and the stout
So skillfully, with such bold ornaments,
The bodies they were born with disappeared,
Dissolved into the perfect lineaments
In which their noble nature is declared.
Making the body advertise the soul,
For all the money and self-discipline
The fashionable need to do it well,
Was surely easier and caused less pain
Than the reverse, which is the task that she
Must manage to achieve without a gown,
Jewels, or the disguise of paint: to be
Noble by personality alone.

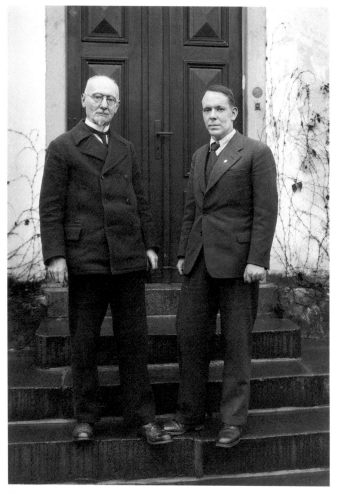

Tannery Owners, 1931

Tannery Owners

Somewhere a bolt is fired into the brain
Of a pale calf that crumples to the floor;
Men with long knives slice off her skin before
The blood can seep out far enough to stain,

Then wash the rawhide in a bucket full
Of lime and ash to melt away the fat,
Scrape off the hair, and plunge it in a vat
Of tannins where it stretches out until,

After a week or two, it's flexible
Enough to make a handbag or a glove.
(Others are tasked with the disposal of
The slurry waste, whose unmistakable

Aroma lingers near the tannery,
Spiking the cancer rate for blocks around.)
But where in all those processes are found
These men, who take responsibility

For all the stink and blood they live among,
Yet stand here looking so immaculate?
The capitalist is the flower that
Perfumes the air to camouflage the dung.

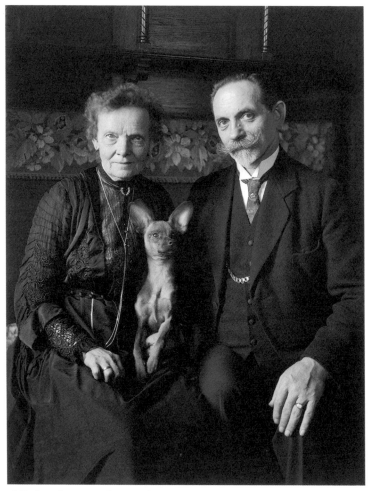

Skilled Tradesman and His Wife, 1923

Skilled Tradesman and His Wife

A golden watch-chain strains against the gut
That is the badge of his prosperity;
The heavy fabric of his three-piece suit,
Her black blouse with its fine embroidery,
Insist the tradesman and his wife are more
Respectable than what they make and sell,
Which could be leather goods or watches or
Some sordid item they won't show or tell.
Emancipated from the life of trade,
They wear the costume of the bourgeoisie
Not as a boast about the climb they've made,
But as a token of the dignity
They've longed for since the day that they were born,
And which at last they've managed to achieve,
Now that they wear the lightless uniform
In which the dignified must learn to live.

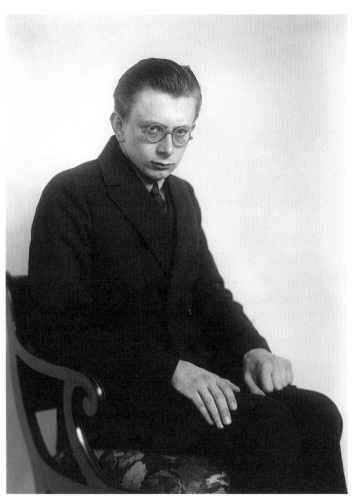

Student of Philosophy [Erich Sander], 1926

Student of Philosophy

Knowledge can only be the knowledge of
This world, which is a tournament of need
For power, status, money, beauty, love —
Things that his face and figure have decreed
Will not come easy, if they come at all.
The weak chin, thinning hair, myopic eyes,
And slouch of his resentful shoulders tell
How early on he came to realize
That he was one of those condemned to know,
While others had the privilege to be —
Spending his life inside the giant shadow
Cast by the real, which his philosophy
Describes as the Idea, the noumenon,
And other honorifics that suggest
The actual's to be looked down upon
By those predestined to the second-best.

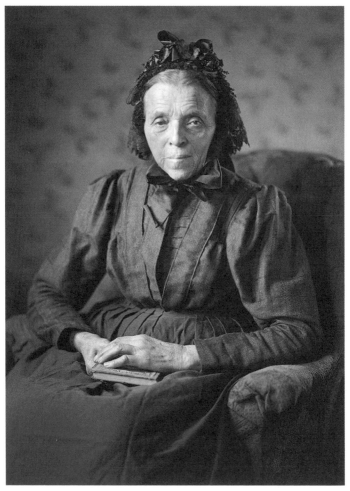

The Woman of Progressive Intellect (Intellectual), 1914

The Woman of Progressive Intellect

If it were not for her enlightened eyes,
She'd be the witch that intellect denies
Has ever walked the earth: the sunken jaw,
The blunt chin like a claw-toothed hammer's claw,
The stubbed and crooking finger, and the skin
As stained and crinkly as her crinoline,
Would make a loving grandchild run away.
It takes another kind of love to see
How spirit, in its tactical withdrawal
From aging outworks that are doomed to fall,
Consents to the bewitching of its shell
As long as it can hold the citadel
Where the progressive intellect has spent
A lifetime plotting the enlightenment
The backward and the beautiful dismiss
As mind's revenge for its unloveliness.

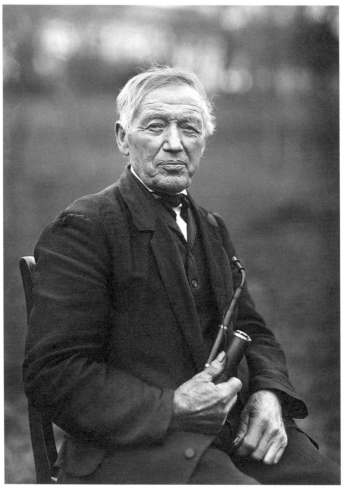

The Philosopher, 1913

The Philosopher

No need to ask what gives him his
Now slightly withered boyishness,
The small smile and the twinkling eye
Through which he sees the world go by
Like a long, complicated joke,
As insubstantial as the smoke
That issues from the saxophone-
Sized pipe he always takes along —
Smoke that in time is sure to bring
The death for which he's practicing
Each time he recollects the realm
Of pure Idea whence we come,
And which it's possible to glimpse
As quickly as the shutter snaps
To document his fall into
The passing world he's passing through.

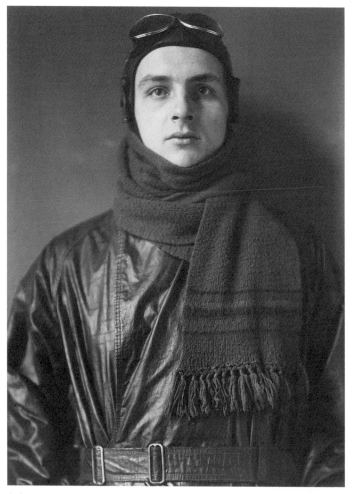

Aviator, 1928

Aviator

Nothing can stay miraculous for long:
After he'd logged a hundred hours among
The clouds that for a hundred generations
Bewitched the impotent imaginations
Of men who lived and died upon the ground,
Even the most romantic pilot found
He barely registered the wisps of white
Beckoning him to that inhuman height,
Reduced now to another province of
The known, which is as tedious above
As down below. The aviator's face,
Solemn with all the bravery and grace
He hasn't yet discovered matter less
Than unimaginative steadiness,
Is what remains of the antique desire
To leave ourselves behind by going higher.

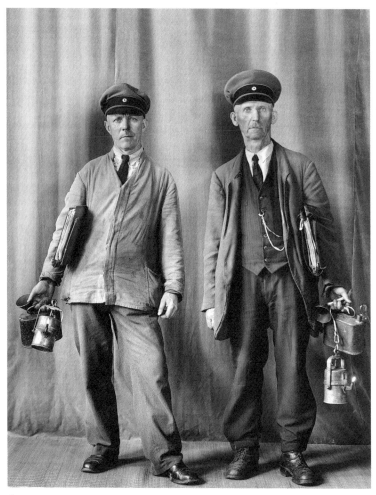

Gasmen, 1932

Gasmen

Unter den Linden wraps itself in shadow,
The stores are closed on the Kurfürstendamm.
Clerks and shopgirls aren't headed home,
But hurry to a restaurant or show;

At five o'clock their real lives begin.
The hour that would have filled their ancestors
With panic and the urge to get indoors
Before the silent darkness gathered in,

Holding what beasts and bandits no one knew,
Is now the second dawn when neon signs
Deface the sky with red and purple lines,
Hiding the obsolescent moon from view.

In lesser streets and half-deserted squares
Where no department store has yet to build,
And which are happy never to be filled
By crowds that make a no-place everywhere,

A different light prevails: a yellow mist
Diffusing itself downward from a cone
Of gas, content to make a little zone
Of light with which the dark can coexist.

Gasmen (cont'd)

This is the gasmen's kingdom. They patrol
With slouching gait and wrinkled uniforms,
Torch, canister, and notebook in their arms
As they enforce their inefficient rule;

The lit ends of their flares, like fireflies,
Jostle and dart in the enveloping,
Pointillist half-dark of the evening,
As if to compensate for starless skies.

The hiss and whisper of the waving jets,
The alphabet of shadows that they make,
Compose a language that the gasmen speak
And which the city's started to forget,

Now that it can no longer understand
Why shadow's needed to complete the light.
The future is pitch-black and shocking white;
The gasmen's world is coming to an end.

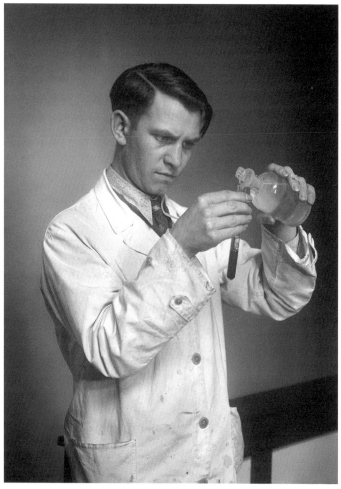

Laboratory Technician, 1938

Laboratory Technician

The man he was that morning on the bus
Or will be when he climbs in bed at night
Has vanished wholly in the fretful focus
Needed to get his calculations right;
Intent on pouring something in a tube,
He strikes the pose we all know from TV
Stands for the scientific rectitude
Of men who wear white coats — which he would be,
If not for streaks of sedimented grime
That turn his own the unhygienic brown
Reserved for common laborers whose time
Gets spent on tasks whose purpose isn't known,
Himself an apparatus to be tossed
Aside when broken or grown obsolete,
His honor and reward to have been used
Without inquiring for whose benefit.

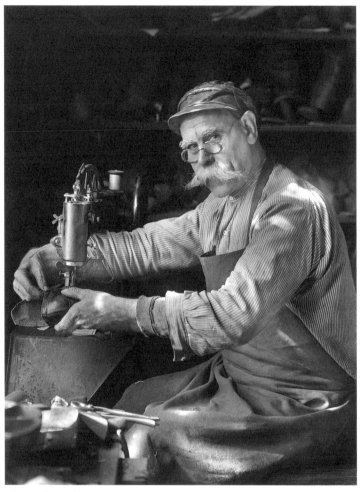

Master Shoemaker, 1925

Master Shoemaker

What happened to the pitch and wax
With which a master like Hans Sachs
Would baste the upper to the sole?
Gone like the melody that made
An aria of the cobbler's trade
When work and workman were a whole.

The rhythm that the hammer's pin
Tapped out against the nail has been
Distended to the monotone
Made by the stainless steel device
That stabs and stabs the leather piece
Until the shoe or boot is done.

By now the master understands
It's not the skill of eye or hand
That makes him function perfectly,
But the capacity to bend
Over a tool for hours on end
And not concern himself with why.

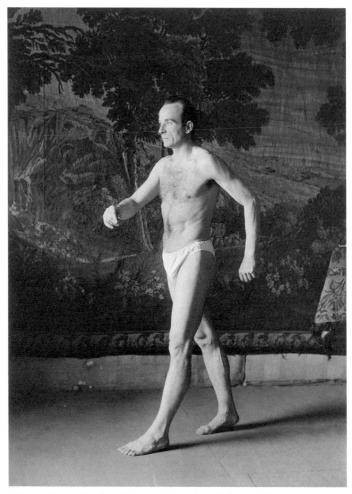

Kinetics Researcher from Vienna [Max Thun-Hohenstein], 1930

Kinetics Researcher from Vienna

Nakedness ought to be undatable,
Proof that the latest phenotype is made
On the same plan as his original
Who sauntered through the Garden, unafraid.

Even without the cotton pouch he wears
As a concession to the prudery
Of viewers not evolved enough to share
His unembarrassed objectivity,

The willed detachment on his face would show,
Better than any clothes, the difference
Between the antique innocence that knows
No shame, and cultivated shamelessness.

III.

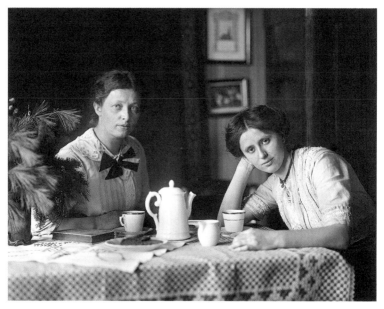

Small-town Women, circa 1913

Small-town Women

Business and law, the church and government,
Making a living, having a career —
Things that their brothers and their husbands spent
Their lives on seem unnecessary here,
In this small parlor where the window's shut
Airtight, and only beams of light convey
News of the world beyond the haven that
They are condemned to occupy all day.
Society once set such rooms aside
As petri dishes for the novelist,
In which the energies of life denied
Were made to decompose and iridesce
Intensely, into visions that the past
Glorified as the inner life, until
The windows were thrown open and we lost
The patience or the taste for sitting still.

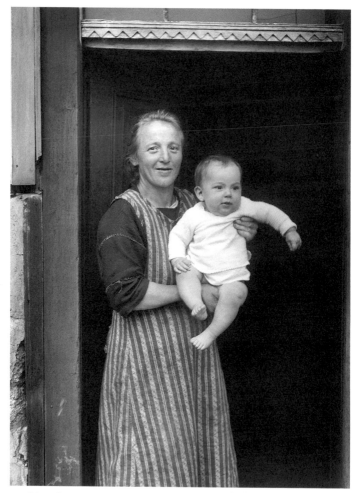

Working-class Mother, 1926

Working-class Mother

Whatever flashing or unlikely thing
The baby boy is beaming at remains
Beyond the frame, forever vanishing,
An emblem of the passing world that feigns
A permanence in which he still believes.
His mother, who has reached the age to know
How quickly our most dear belongings leave —
Having observed her hope and patience go
Until at thirty she looks middle-aged —
Doesn't attempt to hold him back, but holds
Him proudly up and forward like a pledge
To time. If he is eighty-six years old
Today, with all his hope and patience gone,
Having survived when all those millions died
Only to die a little later on,
Her greatest wish will have been satisfied.

Widow with Her Sons, circa 1921

Widow with Her Sons

A boy no older than the Armistice
Can't say for certain if there was a time
When he was not among the fatherless
Who make up half his neighborhood; to him
A mother's someone always dressed in black,
Whose fierce embrace attempts to camouflage
Him and his brother from the stealth attack
Time won't call off until they reach the age
For putting on the field-gray uniform
And helmet-spike they grew up worshipping
In photos on the mantelpiece at home,
Or what new uniforms the times will bring
To certify they've grown up into men
Whose deeds she won't believe or understand,
Her destiny to suffer once again
Her usurpation by the motherland.

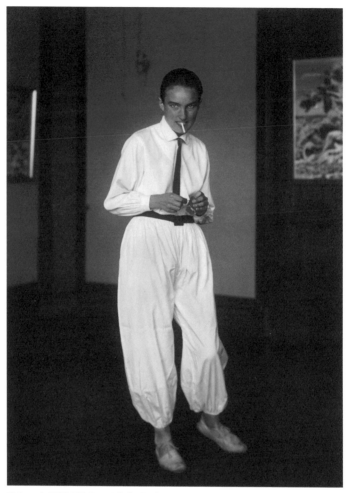

Painter's Wife [Helene Abelen], circa 1926

Painter's Wife

The effort that it took to hide
Her captioned wifeliness inside
A man's short hair, a shirt and tie,
Ballooning trousers belted high
To hide her hips, a cigarette
When nice girls weren't smoking yet,
Is unconcealable. Success
Is knowing what she must transgress
To be considered up to date,
A suitably inventive mate
For some painter we don't see,
Although it's safe to say that he
Does not feel that he has to wear
A skirt or ribbons in his hair
To prove that his bohemian
Bona fides are genuine;
The womanhood that she denies
Returns in what she can't disguise,
The lifelong difference between
His seeing and her being seen.

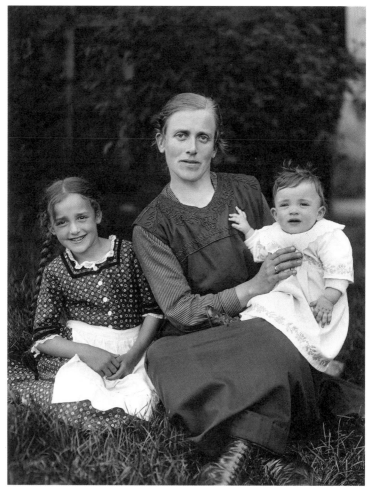

Farm Woman and Her Children, 1920–25

Farm Woman and Her Children

The chain of flowers that runs along the hem
Of his white baby-dress unsexes him,
As though he's not yet ready to commit
Or be committed to the definite,
Reproachable destiny of being male.
He will not be an individual,
Declare the matching flowers on the dark,
Absorbing softness of his mother's smock,
Until he breaks the circuit that his hand
Keeps with the breast he doesn't understand
Is not a part of him, and flings it out
In the aggressively erect salute
He will begin to learn at nine or ten;
Nothing can hope to undermine, till then,
His confidence that she'll protect him from
The monster he is going to become.

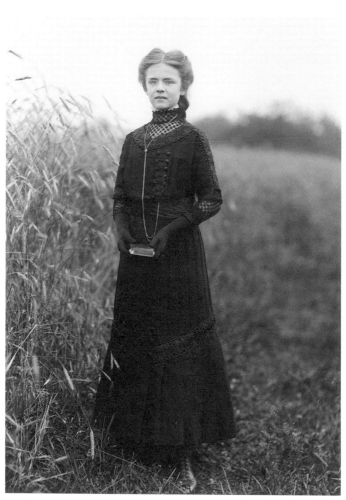

Confirmation Candidate, 1911

Confirmation Candidate

Her clothes are black, her frown is resolute,
As if she had been misinformed about
The nature of the ceremony she
Seems to be going to unwillingly,
As though to her own parents' burial —
Some almost unsurvivable ordeal
For which she'll need each button, stay, and lace
Her mourning dress expensively displays
To keep her upright and to demonstrate
That even death can't make her deviate
From the propriety that she has learned
Is what sustains us when the world has turned
To ash and shadow, which she so resembles.
Only the silver missal that she handles
Shows it is not the churchyard but the church
She's headed to this Sunday—into which
She'll be received more readily for wearing
Mourning for the God whose disappearing
Looked like a death, until the stone was rolled
Away and His enormous absence told.

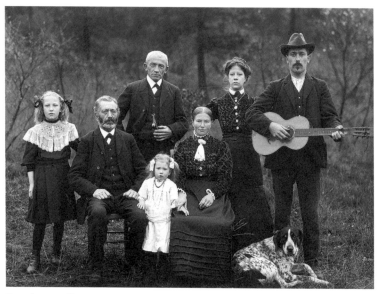

Farming Family, 1912

Farming Family

The cruelty of the men when they're alone,
The women's tiredness and resignation,
Do not get multiplied, as you'd expect,
When the extended families collect,
One day a year, to get their picture taken.
It's not that any of their faces soften,
Nor that there's any obvious affection
Between the farmer's mother and his son;
And only an idealist could see
In this brief cutting from the family tree
A symbol of the strength of rootedness —
Three generations dwelling in one place —
Knowing how soon the root will lose its branch,
Cut down and hacked to pieces in a trench.
The only explanation that makes sense
For the illusion of resilience
That lights their eyes and makes them look at home
Is that with every added generation
Buried potentialities appear:
The son who poses strumming his guitar
Refutes his father's brandished Iron Cross
No more convincingly than his bare face
Proves that his father's beard is obsolete;

Farming Family (cont'd)

Denying one another, they complete
Their likeness to the contradictory
God who commanded us to multiply
So He could manifest, in every birth,
Another of His attributes on Earth.

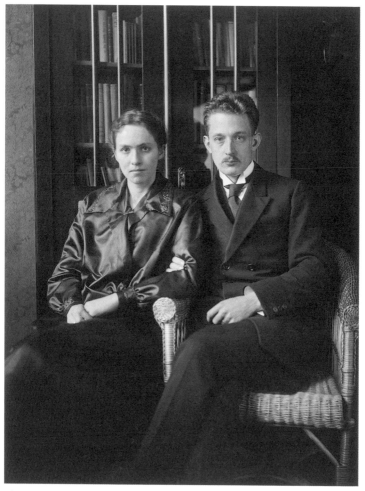

Clergyman and Wife, circa 1929

Clergyman and Wife

Around his throat a loosely knotted tie
Instead of the constraining band of white
That advertised his predecessors' right
To tell their people how to live and die;

No pince-nez or authoritative beard
Deflects attention from the gentleness
His wide-set, meditative eyes express,
The unassuming manner that endeared

Him to the wife whose glossy satin blouse,
Embroidered with a delicate design
Around the collar, seems to be a sign
That she won't be content with keeping house

In some provincial town where pastors' wives
Must be as shabbily respectable
As the old-fashioned and uncomfortable
Vicarages where they spend their lives.

Like missionaries, they adopt the dress
Of those they've been assigned to live among,
The debonair and church-despising young,
Drowning in an unnamable distress,

Clergyman and Wife (cont'd)

Who might accept from them what goes unheard
When droned from stuffy pulpits from on high —
The good news that their faces testify
Lives in the never-obsolescent Word.

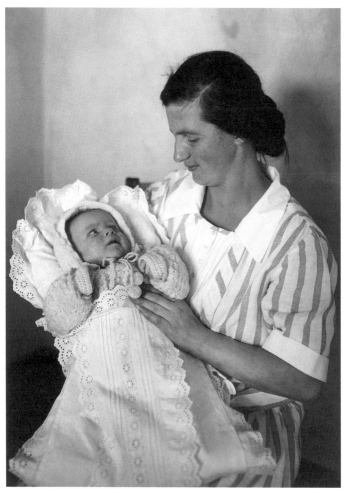

Mother and Child, 1926

Mother and Child

Newly introduced, they try
To feign familiarity
By taking up the stereo-
Typed pose the viewer's come to know
From all those painted Marys and
Their haloed babies grasping hands,
And gazing in each other's eyes
With a sad trust that promises
That he will grow up to reject
The mother who will genuflect
Before his cruel dismissive words,
Biding her time till afterwards,
When his torn body can't refuse
The tenderness she lavishes.

The pose is right; but no one told
The newborn he's supposed to hold
His mother's gaze contentedly,
Not with this disbelieving eye
And trembling mouth that seems about
To let a wail of terror out,
As though she were a stranger who
Had taken him from all he knew—

Mother and Child (cont'd)

The plush womb with its steady roar,
And the non-entity before
In which he had been so content —
And at some brutal whim had sent
Him weeping to the world outside
Where boys are born and crucified.

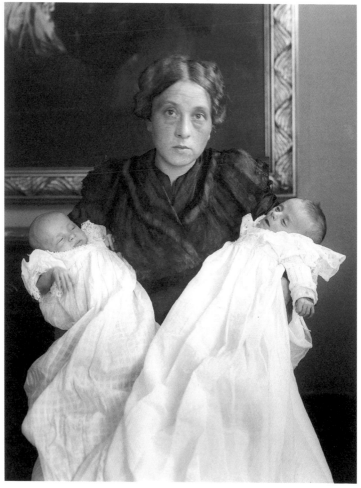

My Wife in Joy and Sorrow, 1911

My Wife in Joy and Sorrow

1.

Bewildered now to be so unalike,
Who were for one another from the start
The kind of perfect double that we all
Long for in life, and learn to do without,
Their first reaction is to counterfeit
Each other's posture; but they manage it
Too well, so that they end up changing places:
This one, alive, has shut his eyes and mouth
As if to camouflage his consciousness,
While that one, dead, with open mouth and eyes
Seems to take in the world that shuts him out.
Mothers, of course, are never really fooled
By pranks like this; the baby that's alive
Is lighter on her arm, as if the soul's
Weight were a negative, a lightening,
A counter-force to gravity, which drags
The unsouled body downward to the earth
That soon enough is going to be its home.

My Wife in Joy and Sorrow (cont'd)

2.

The joy is that there is one left alive;
The sorrow that one didn't know enough
To fend for itself even for an hour.
Or else, the joy is that one is discharged
So soon from liability to pain,
Never to know the kind of agony
Its mother's dull, exhausted eyes betray,
Thinking of what awaits the one who lives.

3.

What kind of father asks his wife to hold
Her dead child and her live one in her arms,
Then poses her and fiddles with the lights
Until the shot is perfectly composed?
Doesn't he see the angry misery
With which she's staring at the lens, as if
To ruin the picture by sheer force of will?
Or is it just this that he wants to capture,
An accusation that he brings against
Himself, the artist who is always free
To stand outside the frame, outside the life
That tortures others and that he observes
As though he were as little part of it
As the dead baby in his photograph?

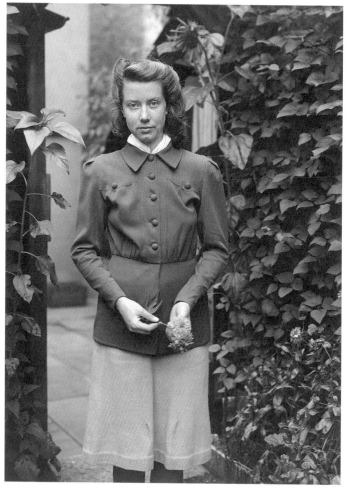

Girl, 1943/44

Girl

An atavistic taste for symbol posed
The young girl, who is not so very young,
Inside a bower and handed her a rose
To put italics on her "blossoming" —
The biological celebrity
Her mother and her mother's mother owned
And gloried in until it had to be
Cashed in for the inevitable husband.
Yet the distracted way she holds the stem
And slightly fails to meet the viewer's eye
Suggest she hopes she'll be as different from
Those icons of contented chastity
As their high hair and petticoats from her
Unpainted face and military blouse,
Which hint her generation has in store
A fate less lovely and more serious.

IV.

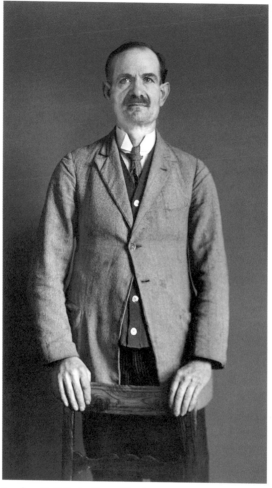

Leader of a Splinter Party [Dr. Braun, German Federation of Intellectual Innovators], 1931

Leader of a Splinter Party

There was a time when men as clearly mad
As this would be avoided in the street,
Or pacified with an indulgent nod
As he described the glory of the fate
His plotted-against nation had in store,
His volume climbing as the audience,
Busy and having heard it all before,
Would drift off in amused indifference.
The supernumerary's meant to cheer
And wave a flag while the protagonist
Makes the big speech declaring peace or war;
Exchange them and the state cannot exist,
As when a cell, deep in the breast or bone,
Throws off its native insignificance
And claims the right to multiply its own
Masses regardless of the consequence.

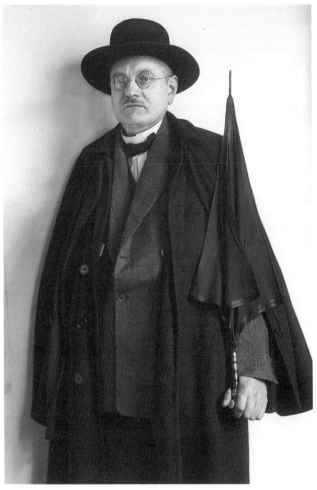

Member of Parliament (Democrat), 1927

Member of Parliament (Democrat)

Here is the vanished nineteenth century
In all of its complex civility:
His upright bearing, clerical cravat,
The overcoat around his shoulders that
Declares he is unused to moving fast,
Even when he is hectored or harassed.
The seriousness of affairs of state
Demands he be as sober in debate
As he is in his wardrobe and expression,
Knowing self-government is self-possession —
Upright as the umbrella that he takes
In rain or shine, in case he wants to make
A gesture or to emphasize a word.
The others carry sidearms or a sword.

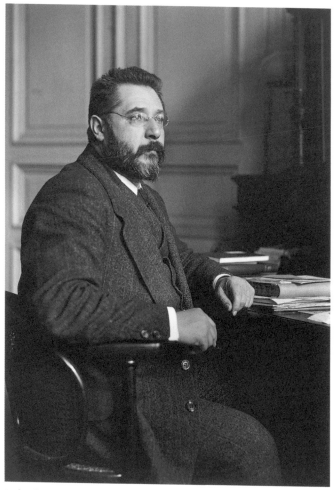

Iceland Scholar and University Librarian [Heinrich Erkes], circa 1914

Iceland Scholar and University Librarian

When even minds are mobilized,
The chemist who taught crops to grow
Must wreck the fields he fertilized
With clouds of chlorine gas that mow

Down men like stalks of rotten corn,
Whose offspring the demographer
Now calculates will not be born,
Costing the government its share

Of future population growth
Which the joint chiefs of staff require
To feed them new supplies of youth
To throw into the line of fire,

Where the historian has taught
Them they'll fulfill the destiny
The poets now go on about
In lines of morbid majesty.

Doomed to be useful, all of these
Are racing to subordinate
Their various forms of expertise
To the imperatives of state.

Iceland Scholar and University Librarian (cont'd)

Prudent or pure enough to know
Not one thing that could be of use,
Only the scholar dares to show
Himself to time without excuse,

Having done nothing but to gaze
Into the northern distance where
The skald recites his song of praise
Guiltlessly to the frozen air.

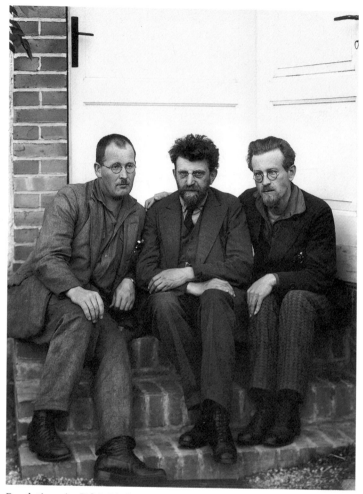

Revolutionaries [Alois Lindner, Erich Mühsam, Guido Kopp], 1929

Revolutionaries

Twelve years on, the beard that Lenin wore
Still sharpens revolutionary chins
To dagger-points held ready for the war
In which the outgunned proletarians
Will triumph thanks to these, their generals,
Whose rounded shoulders and round glasses say
That sedentary intellectuals
Raised in the bosom of the bourgeoisie
Can also learn to work — if not with hands,
Then with the liberated consciousness
That shrinks from nothing since it understands
What's coming has to come. The monuments
To which the future genuflects will bear
These faces, so intelligently stern,
Under whose revolutionary stare
Everything that is burnable must burn.

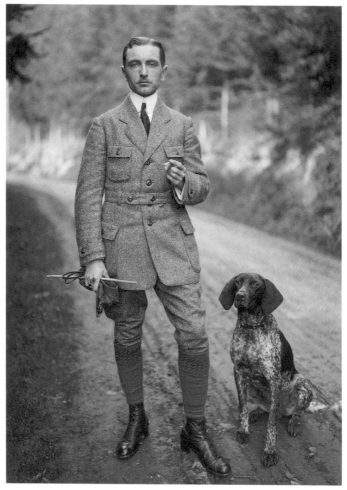

Village Schoolteacher, 1921

Village Schoolteacher

After five years of unremitting praise
For shitting, burping, crawling, standing up,
What child's prepared for his disdainful gaze,
The stinging whistle of his riding crop?
The class learns from the dog's mute watchfulness
How to anticipate their master's mood,
Needing to read that disapproving face
If they are going to be what he calls good,
Which means sly, passive, easy to control —
The very qualities that they will need
When they're grown-up enough to play the role
Their village education has decreed
Is all that they are fit for or deserve.
His is the face the world will always show
To those whose destiny it is to serve,
Frowning as it prepares to deal a blow.

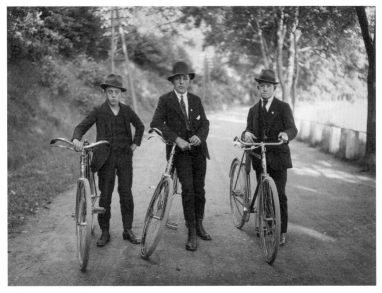

Young Farmers, 1926

Young Farmers

Early one evening in a country lane,
These farmers' fathers' fathers could be seen
Leading their horses homeward by the reins,

Dressed in the battered homespun uniform
Suited to lives of labor on the farm,
The same their peasant ancestors had worn;

Tipping their hats, they wouldn't meet your gaze,
Having been taught it's impudent to raise
Their eyes directly in a stranger's face.

The young ones register a difference:
Having exchanged the rustic's diffidence
For the almost aggressive confidence

That comes with bicycles and store-bought clothes,
They meet the camera with a sneering pose
They have adopted from the cinema's

Imported gangsters, whose sleek tommy guns
Linger in their imaginations once
They have returned to tending cows and hens.

Young Farmers (cont'd)

After a childhood filled with flags and lies,
With more to come, why shouldn't they despise
The country pastor's lamb-like homilies?

Meek and despised for generations, they
Intend their slouch and steely eyes to say
The future's theirs. They will not look away.

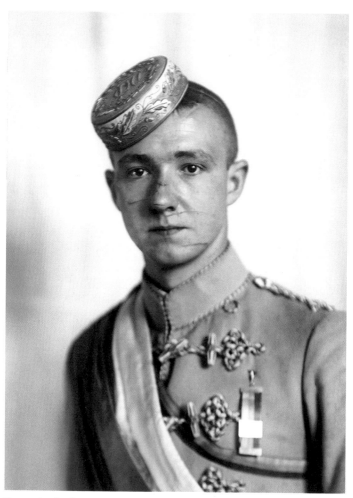

Fraternity Student, 1925

Fraternity Student

The rhetoric of self-discovery,
Enlightenment, becoming fully human,
Had mesmerized the nineteenth century
Into believing that a bunch of common
Teenagers cloistered in a college town
For years of drinking beer and reading Kant
Would come out having molted cap and gown
As a new species — one that wouldn't want
Or need to prove that they are really men
By fighting duels in order to be scarred
With vicious slashes on the nose and chin,
To show the world that they've absorbed the hard
Curriculum no teacher understands
Is what their generation's going to need:
Keeping quiet, following commands,
Stopping at nothing, knowing how to bleed.

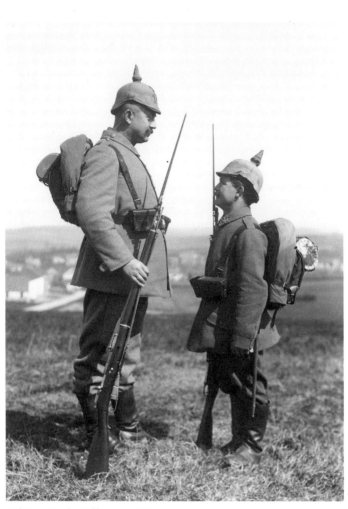

Military Height Differences, 1915

Military Height Differences

Whether it was supposed to be a joke,
A recollection of a fun-house mirror
That shrinks and stretches people as they look,
The way the mismatched infantry appear
As rhymes or parodies of one another —
Laurel and Hardy clutching bayonets —
Reveals the iron logic of the slaughter
That starts by choosing only the most fit
To wear the uniform and helmet-spike —
The tall and lithe, the masterful and tough,
Who show the world what heroes should be like —
But before long decides it's good enough
To hold a rifle and to have a pulse,
Having discovered tall and short, when they've
Been pulverized or torn in half by shells,
Will both fit nicely in a standard grave.

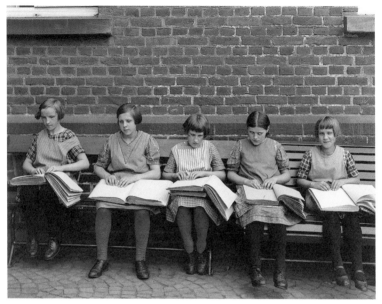

Blind Children at Their Lessons, circa 1930

Blind Children at Their Lessons

Most of perception is superfluous,
The mindless drilling of the ear and eye
To recognize the things the universe
Lavishes with a dull redundancy:
The forest keeps reiterating trees,
Tables repeat the elements of tables,
While spirit yearns for what it never sees,
The paradigm that vision is unable
To find and cling to, though it must exist,
To keep the visible from decomposing
Into a stuttered *this* and *this* and *this*.
The mere appearances these girls are losing
Behind their eyelids permanently shut
Make up a language that cannot be read,
Unlike the one their fingers have been taught,
Whose signs are made to be interpreted.

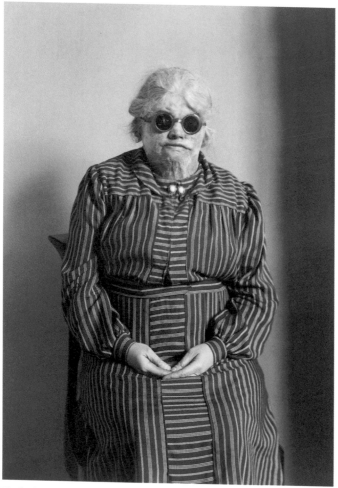

Explosion Victim, circa 1930

Explosion Victim

The gravest injury that can be done
To mind is to remind it that it lives
As the abstract epiphenomenon
Of an electric discharge in the nerves,
And not, as it is happily convinced,
As pilot or as monarch of the body,
Which carries it, not like a pampered prince
Borne on a litter through a conquered city,
But like a galley slave who is condemned
To move inside the ship that he makes move —
Something she didn't start to understand
Until the fiery fist of the explosive
Made a distorted horror of her face,
Inscribing it with scabs and scars that seem
To prove the body offers no redress
For mind's incessant, ineffective scream.

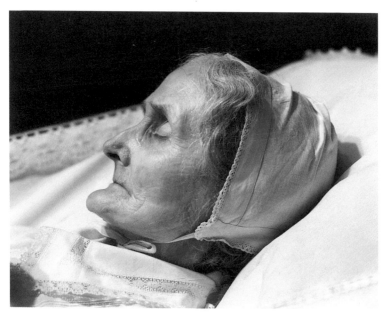

Matter, 1925

Matter

The wick is matter and the ash,
But not the momentary flash;

The rods and cones that take the light,
But not the fullness of the sight;

The neuron's intermittent pulse,
But not the stream of consciousness.

All these demurrals try to hide
The truth that we cannot avoid

When face-to-face with her whose flame
And sight and thought won't come again,

That matter's not an envelope
The soul can put off and take up;

Matter is everything we are,
The dead husk and the living core

Which entropy ensures will come
Into an equilibrium,

Turning the soul into a thing
Like her, beyond all suffering.

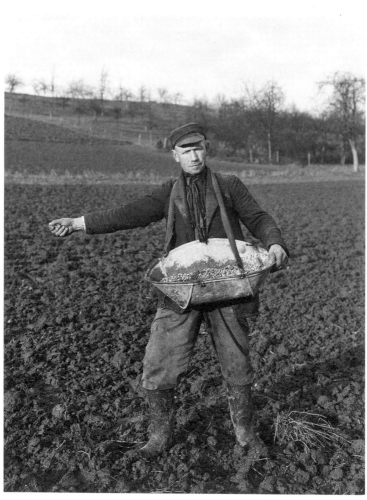

Farmer Sowing, 1952

Farmer Sowing

Cities are destroyed by fire
And rise again;
Conquering armies melt away,
Hemorrhaging men;

Leaders proclaim a government
To last forever,
Then walls collapse and refugees
Come pouring over.

Everything passes; he remains
Casting the seed,
Changeless and inescapable
As human need.

Merchant's Clerk, 1912

Merchant's Clerk

Nothing that is worth saying can be said
In the curt captions that identify
The date and occupation of the dead,
Without even a name to signify

That there was more to him than "merchant's clerk"
Can capture, with its sullen implication
That once you've been informed about his work
You can deduce the rest: the education

He didn't get to have; the boardinghouse
Where he was glad to be allowed to stay,
Though dingy and unheated; the abuse
He took from boss and customer all day;

The years and years of adding up the price
Of produce, dry goods, ladies' shoes, or linens —
We aren't told what kind of merchandise
He sold, as if it didn't make a difference —

In any case, things he could not afford;
With luck, his own small shop; more likely, though,
Given his age in 1912, the war
That used him up and spat him out a "hero,"

Merchant's Clerk (cont'd)

Crippled or mad or dreaming of revenge,
Or else a corpse beneath a wooden cross.
When history itself seems to arrange
A life so that its destiny is loss —

As if there's an alternative to losing,
As if our lives, after a century,
Will not become an equally depressing,
Equally laughable case history —

How to explain the living radiance
That flashes forth from this dead man, who seems
Not to believe in insignificance,
As if he knew we all will be redeemed?

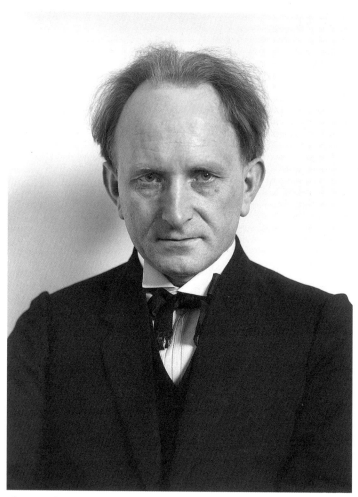

Photographer [August Sander], 1925

Photographer

The photograph of the photographer
Does not resort to posing him with tools,
The flashbulb or the lens that might declare
He is his job, like everybody else
Who passed before the categorical,
Silent tribunal of his black and white,
Whose verdict is as unappealable
And little to be argued with as sight:
What you appear to be is what you are,
Despite the pleas of subjectivity
Whispering there is more to you by far
Than the mere object you're compelled to be
As soon as his remorseless shutter clicks —
Unless, perhaps, he secretly agrees
A man cannot be known by how he looks,
Only by the infinity he sees.

GRATEFUL ACKNOWLEDGMENT is made to the publications where the following poems first appeared:

Battersea Review: "Office Worker," "Painter's Wife," "Laboratory Technician"

Hudson Review: "Working-class Country Children"

Jewish Journal: "The Man of the Soil," "The Philosopher"

New York Review of Books: "Widow with Her Sons"

Paris Review: "My Wife in Joy and Sorrow"

Poetry: "Farming Family," "The Woman of Progressive Intellect," "Kinetics Researcher from Vienna," "Professional Middle-class Couple," "The Butcher's Apprentice," "Revolutionaries"

Think Journal: "Farm Woman and Her Children"

Times Literary Supplement: "Girl," "Middle-class Child"

I am especially grateful to Rajka Knipper of Die Photographische Sammlung / SK Stiftung Kultur, Cologne, for her help in obtaining permission to reproduce the photographs of August Sander.

ADAM KIRSCH is the award-winning author of several books of poetry and criticism, including *Invasions: New Poems* and *Rocket and Lightship: Essays on Literature and Ideas*. His writing has appeared in *The New Yorker, New Republic*, and *New York Review of Books*, among many other publications. He is a columnist for *Tablet* and directs the master's program in Jewish Studies at Columbia University.

AUGUST SANDER (1876–1964) was one of the most important photographers of his generation. His monumental series of portraits, *People of the Twentieth Century*, incorporates hundreds of photographs taken over decades, offering a systematic cross section of the German society of his time.

11/15-#
7116 W